Rock Painting
With Reva

To order additional copies of this book, contact:
Xlibris
844-714-8691
www.Xlibris.com
Orders@Xlibris.com

ISBN: Softcover 978-1-6641-8578-4
 EBook 978-1-6641-8574-6

Print information available on the last page

Rev. date: 07/19/2021

CONTENTS

The author and the publisher make no representation with respect to the accuracy of the contents of this work. Xlibris and the author disclaim any liability for any injuries or damages caused in any way by the content of this book. The strategies contained herein may not be suitable for every person or situation. Readers should be aware that internet websites listed in this work may have changed between the time this book was written and the time it was read. This book is written for beginners. It is recommended that children be supervised while working with the projects.

Thanks to my grandson Jay Luxenberg for his generous help with the illustrations and to Edward R. Levenson for his editing.

ROCK PAINTING WITH REVA

Reva Spiro Luxenberg

INTRODUCTION

Once upon a time when I was a young child my chocolate-brown eyes spotted an interesting big rock. I bent down, picked it up, not anticipating that it would be so heavy that I couldn't keep holding it. I dropped it on my big toe. "Ouch," I cried with pain. I was so embarrassed that I didn't tell my mother. I remember that incident as if it happened today.

I didn't touch another rock until I became a grandmother and learned that some rocks are perfect for painting. For years I had painted pictures on canvas. Some pictures were 8" x 10" or 16" x 20," but some were as large as 24" x 48". The large number of paintings resulted in a major problem for me. I had a limited amount of wall space in my home, and I had painted more pictures than I could hang. A friend of mine told me she paints small rocks. Since rocks don't take up much space, I turned to painting rocks.

You don't have to be an artist to create colorful works of art. Painting rocks is simple enough for children to enjoy, to progress in, and to develop their own styles and designs on them. Just searching for rocks alone is fun. If you live near the seashore, you can gather stones on the beach. If you're lucky enough to live near a river, you will have the opportunity to pick up lovely ones there as well. The flowing water has made them smooth to the touch. Lakes are also ideal for those collecting stones.

River rocks can be sedimentary, igneous, or metamorphic.

Sedimentary rocks are formed by the accumulation of particles, mineral or organic, on the Earth's surface by mass movement, ice, water, or wind. You will be using the sedimentary rocks.

Igneous rocks are formed through the cooling and solidifying of molten materials. They can form beneath the Earth's surface, or as lava on its surface.

Metamorphic rocks are derived from sedimentary or igneous rocks that have recrystallized as a result of changes in their physical environment.

When you decide to bake a cake, you need to gather flour, sugar, eggs, shortening, baking powder, salt, and vanilla extract. After the cake is baked, it is delicious. What's the problem? Once you eat it, it's gone. No more cake. Once you paint a rock, however, it lasts forever.

This book is a guide for beginners and is written in an easy-going style. Why? Because life can be complicated and I, for one, like to make it as simple as possible. At one time I was what was called a "clothing" teacher in a junior high school. I taught sewing to girls, as well as boys. I realized that patterns and instructions for making a garment were complex and intricate. I devised a method that simplified the whole process. I used easy patterns. For example, I avoided patterns with set-in sleeves. The students were satisfied when their garments were finished. They put on a show for all the students in the auditorium modeling their clothes. I was overjoyed with their accomplishments.

CHAPTER 1

SUPPLIES

ROCKS

Maybe you don't live near a beach, a river, or a lake. This means you have to get the most important component in another way. The easiest method to obtain rocks is in a garden supply store or, as I have done, by ordering them online through Amazon. They come in a wide variety and they're surprisingly inexpensive. The rocks are clean and don't necessarily have to be washed—perhaps, just rinsed. Start out with rocks that are two to three inches in diameter. Buy some round ones and some oval ones. Michael's craft stores carry rocks. The company features an absorbing video demonstration on line.

PAINTS

You need paints, of course, to apply to your rocks. Acrylic paints are wonderful. They dry quickly and come in vivid colors, even metallic. Basic colors come in tubes. All paints are obtainable in small bottles. Liquitex and Artist's Loft are reliable brands. Children need to wear aprons since acrylic paints don't wash off fabrics.

PAINT PENS

I'm so enthusiastic about paint pens that I could do a jig. (Maybe just a few dance steps because I don't really know how to jig.) Paint pens are easy to use. You give them a shake to loosen the paint and you're ready to go. The ones I use are made by POSCA and they come in a plastic container with twelve

basic colors. The only English word that appears on the package is POSCA and the rest of the writing is in Japanese. We can thank the Japanese for making such an awesome product. When you become an advanced student of rock painting you will have more choices of paint pens. MISULOVE sells metallic-colored pens with water-based ink that are long-lasting and non-toxic. STAEDTLER has a fine-liner paint set with ten colors. Each marker has a 0.3mm dimension, which is very fine for a marker pen. If you wish to write on your rocks, you can buy a calligraphic pen.

BRUSHES

You need a set of brushes for your acrylic paints. You won't be using them a lot since you'll depend mainly on your paint pens. However, there are times you may use one for your background. Remember that you need at least a half-hour for the paint to dry before you draw your picture.

WIGGLE EYES

Get a package of assorted sizes of wiggle eyes. You'll be using them for the cute animals you'll paint.

GLUE

You'll need glue to attach the wiggle eyes. I've tried different kinds and find that Gorilla Glue is the best. You can use cotton swabs to apply the glue.

STYLUS

One type of stylus is a ball-ended tool that's used to create dots. You'll get a kick out of making all sizes of dots on your projects. I have a set of these styluses, but I don't use them so much for dots because I once tried the pointed end of one of my brushes and I was delighted with the way *it* made dots. A stylus with a rubber tip may be employed for touch-screen use as a substitute for fingertips.

PALETTE

A palette is where you spread out your paint blobs. If you want to pretend you're a great artist you can buy a palette. I found that I can use a small disposable paper plate. When I finish painting I take my paper plate and daintily drop it into the garbage.

DECOUPAGE

To protect your finished work you may paint decoupage over the surface of the rock. I use Mod Podge. I feel embarrassed to reveal that most of the time I skip this step due to laziness. However, if my conscience bothers me so much that I can't sleep, I'll get out of bed in the middle of the night, take a brush and apply the decoupage to the rock. I use Mod Podge with gloss and I admit it does make my projects more attractive.

MAGNETS

You may choose to glue tiny magnets to the back of your small rocks. You then can proudly display them on the front of your refrigerator.

CHAPTER 2

MANDALAS

A mandala is a spiritual symbol, a visual representation of the universe. It may be used as a guide in meditation. Mandalas dating from the fourth century to the present have been produced in Bhutan, China, India, Japan and Tibet. Literally, "mandala" means "circle." The circle is without a beginning and an end, just as the universe is believed to have no end.

I'm starting you off with mandalas for a few reasons. There's no need to outline a picture on your rock. Any size rock is good for a mandala. You start off with a circle in the middle and create a design that pleases you. You may use any colors that you like. You may add dots or flowers or leaves. It's truly your choice. I've painted more mandalas than any other designs probably because I like the easy way of doing things.

I painted my first mandala on a flat white rock. When I started out, I didn't have a clear idea of what I was going to do. I kept surprising myself. When I completed the design, I outlined the forms with a black pen. I decided it would look better with some dots. I had used eight colors. If you don't like your design, you may paint over it when it dries.

You may design a paperweight to secure your papers. I used a four-pound rock for an unusual mandala piece that I made. Such a rock makes a thoughtful gift that's a beautiful addition for a desk.

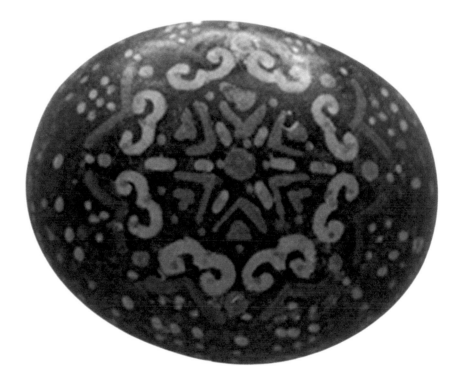

CHAPTER 3

ANIMALS

Mandalas are easier to create, but real critters need an extra step for the design. Start out by deciding what creature you want to draw. Next step is to draw it on a piece of paper. Practice perfecting it to your satisfaction. Then draw the outline on the rock with a pencil. Start painting the project. If it's not to your liking, cover what you've done with paint and start over.

I've illustrated different animals in this chapter. I have a picture of an owl, a monkey, a cat, a dog, a bird, a fish, a ladybug, and a butterfly. My favorite is the ladybug since I attached wiggle eyes to it and gave it an attractive personality.

OWLS

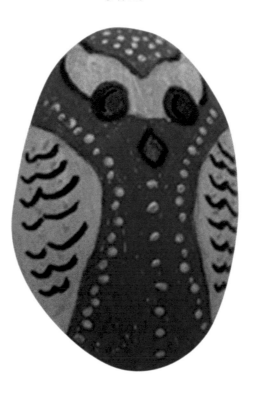

Owls are solitary nocturnal birds of prey with large broad heads and an upright stance. They're a symbol of wisdom, silence, and fierce intelligence. When I was into making stained-glass projects, I created a stained-glass owl with huge orange glass eyes. I'm fond of the poem "The Owl and the Pussycat." It's a nonsense poem by Edward Lear in which a cat proposes marriage to an owl. That's why it's labeled "nonsense."

MONKEY

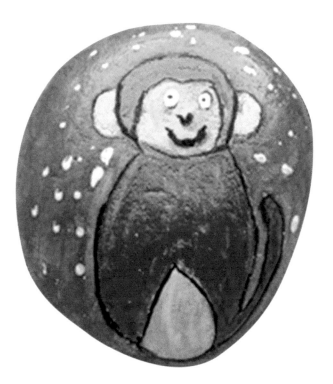

The name "monkey" may refer to groups or species of mammals. Monkeys are considered to be some of the most intelligent animals on this planet. Since they're trainable and like to interact with humans, they're great candidates for film-making and are often portrayed as characters in stories. They use tools like humans. Often they live a harmonious social life. Many monkey species are tree-dwelling. Many of them are mainly active during the day. I used to say to my children "stop monkeying around," meaning don't get into mischief as monkeys often do.

DOG

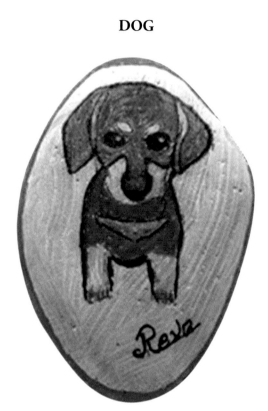

You may decide to paint your oval rock white as a base for your drawing. Don't be hard on yourself if your sketch isn't perfect. You're not painting the *Mona Lisa*—only the likeness of a dog. Dogs are descended from a now-extinct wolf. It's interesting that the dog was the first species to be domesticated more than 15,000 years ago. Over millennia dogs have been selectively bred for different behaviors, sensory capabilities, and physical attributes. Just watch the dog shows on TV and you'll see that dogs that widely in color, shape, and size. Dogs hunt, herd, pull loads, offer protection, and assist police and the military. They are wonderful companions, and they also aid disabled people and have therapeutic roles. Truly, dogs are "man's best friend."

CATS

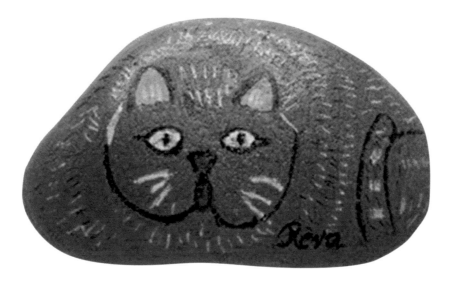

Approximately 220 million cats are said to be owned by humans. I wonder who took that census. Maybe there are more, maybe there are fewer. As of 2017, the domestic cat was the second-most popular pet owned in the United States. My cat Fluffy hung around my home until she owned me. I painted the above cat on an oval rock, giving it a brown background. I drew the face and the tail with a pencil and then filled in the features with a colored pen. But, of course, you can make any kind of cat you like.

Cats were first domesticated around 7500 BC. From 3100 BC on ancient Egyptians domesticated and venerated cats. The cat is a solitary hunter but a social species. Their communication includes meowing, purring, trilling, growling, grunting, and hissing. Cats hear sounds too faint or too high in frequency for human ears.

I also had a cat that I named Houdini as he was able to get out of tight places. My son had found a kitten that the mother had rejected. He brought it home and said, "Here's a birthday present for you, Mom." It was in a closed box. I answered, "My birthday isn't for a few weeks. I'll put this box in the refrigerator." "Don't do that!" he said. That's how I found out what was in the box.

FISH

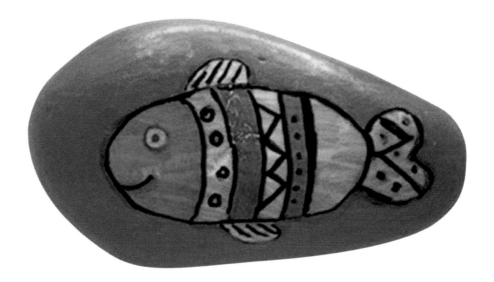

I used an oval rock for my fish painting. I like the gold background and the decorations on the body. My fish is smiling. You'll discover that it's easy to draw a fish.

Over the years I've owned quite a few aquatic animals that don't have limbs. Most of them were goldfish. I find looking at them as calming as looking at a rainbow after a storm.

Fish can communicate in their underwater environment. Their colors give different signals to other fish, like "Hi there." Paint your fish any color you like.

BIRDS

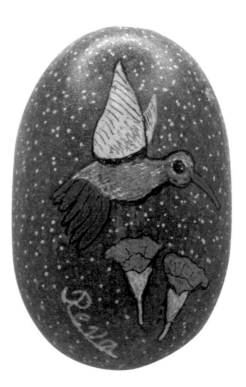

I painted this bird on a large oval rock. You can see rock is gray as I didn't paint a background color on it. I added a couple of flowers and many small colored dots. I enjoy making an array of dots.

LADYBUG

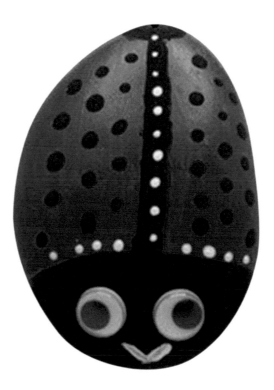

I must say that this rock is one of my favorites. Notice the glued-on wiggle eyes and the smile. Many cultures consider ladybugs lucky. They're kind of cute, aren't they? That's why they may be valued as lucky.

The name "ladybird" came from Britain where the insects became known as "Our Lady's bird" or the Lady Beetle. Ladybugs/ladybirds occur in the major crop-producing regions of tropical and temperate countries.

BUTTERFLY

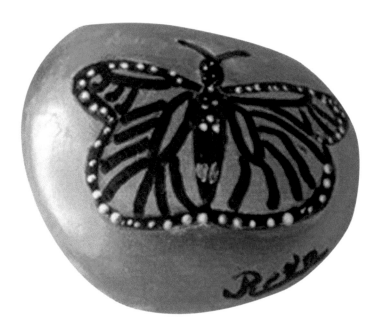

Butterflies are widely used in art as they are so brilliantly colored. You can go wild with your imagination by painting your butterfly any color you wish. Butterflies appeared in ancient art in Egypt 3500 years ago. One of my favorite operas is *Madam Butterfly* by Puccini. The word Butterfly refers to the young Japanese bride, not the insect.

Butterflies start out as caterpillars. When I was a child I collected caterpillars. One such caterpillar turned into a butterfly; and to my dismay, it just flew away and disappeared on the spot.

My butterfly has a background of metallic copper. I put yellow dots on the wings and I let the background show through for its body.

If you admire butterflies, you may find yourself painting quite a number of them indeed.

CHAPTER 4

FIGURES

It isn't difficult to paint people's heads. Just look in the mirror and paint yourself. I don't look like this figure, but she does resemble a neighbor of mine.

You need eyes, ears, a nose, a mouth, and hair of whatever color you choose. Just experiment.

CHAPTER 5

PLANTS

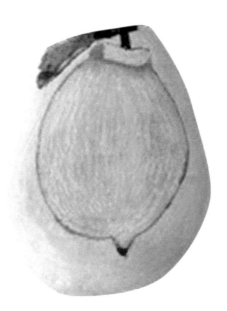

I was inspired to paint a lemon by what my son reported to me. He was determined to raise a lemon tree in his house. He knew nothing about how to do this since he's a computer whiz. He calls himself "The Computer Doctor." He watched U-Tube and followed their instructions on how to prepare lemon seeds. He was successful enough to grow a small tree indoors. It grew to be seven feet, but the weather turned cold so he moved it to his heated garage where it thrived enough to sprout three green lemons. My son is so enthusiastic about his lemon tree that he's debating with himself whether or not he missed his true vocation in not becoming a farmer.

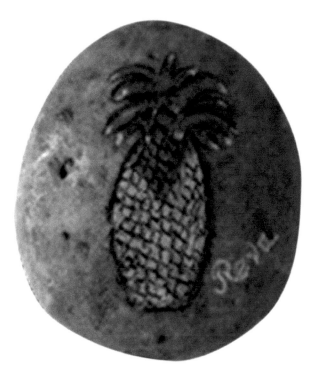

Pineapples are fun to draw. An interesting note is the phenomenon of the crevices on the rock, which, ironically, complement the grooves in the pineapple.

CHAPTER 6

LANDSCAPES

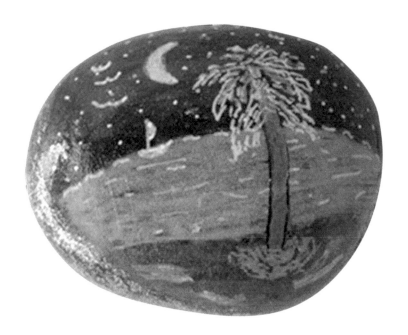

I used a large rock for this landscape. My imagination created a sea with a sailboat, stars, and a moon—and a palm tree on the shore.

CHAPTER 7

HOUSES

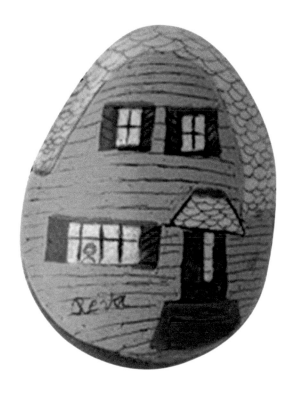

Houses are fun to create. You may choose the colors that capture your fancy and put in as many windows that you want. Notice that there's a person peeking out the front window. I always liked houses as I grew up in an apartment building.

For my roof I chose a U-shaped layer of green shingles. You can even put some snow on the roof, the windows, the top of the door, and the ground. How about building a snow village with a few more rocks? A rock snowman will make it look even more festive.

For the windows I added rectangular shutters on each side.

CHAPTER 8

WRITING ON ROCKS

"How's everything, Mike?" I asked a friendly policeman of my acquaintance. His expression was one of sadness.

"My wife is sick," he answered.

"Sorry to hear that. What's her name? I'll say a prayer for her."

"Thanks. Her name is Lily."

When I got home, I took one of my rocks and wrote "Lily" on it. I decorated it with flowers and the next time I saw Mike I gave him the rock to give to his wife.

The following week when I approached Mike his face lit up when he saw me. "Lily is feeling much better. She can't get over the rock you made. She keeps it on the night table next to her bed. She appreciates it very much and sends her thanks."

You can do the same thing with your rocks. You can write words on them and give them as gifts.

One time when I was a teacher I wrote the homework on the blackboard. I stood back and was dismayed to see my handwriting. I was so embarrassed that I made up my mind to teach myself to write so well that I would be proud to display my words.

At the library I checked out books on handwriting. I liked the look of calligraphy, which means "beautiful penmanship." Its basic characteristic is the elegant tracery of the thin and thick strokes of the letters used. During the Middle Ages the monks developed the art of calligraphy in their dark, musty cells. Then along came the invention of the printing press around 1450, and calligraphy started to decline. By the end of the 16th century the number of calligraphers had substantially dwindled. We can thank Edward Johnston for reviving calligraphy in 1906 with his book *Writing and Illuminating and Lettering*.

The revival continued, but it was only during the 1970s that calligraphy enjoyed an upsurge in popularity. It has not yet peaked and maybe never will. This revival has been termed one of the greatest artistic phenomena of the 20th century.

After studying many books I had concluded that I would create a new system of calligraphy that would be simpler than the others but still beautiful. I worked on the letters of the alphabet—both lower case and upper case—each one for three weeks until I was satisfied with the result. I named my system Romantic Calligraphy and published a book called *Calligraphy for Lovers*. It was a teach-yourself method of attractive writing. I'm incorporating it into this book.

You will need a felt-tipped calligraphy pen that will give you the characteristic thin and thick lines if you hold it correctly. The broad part of the tip of the pen should hit the paper at a 45 degree angle. You will need a minute minder and lined paper. A minute minder is a timing device that can be set to ring or buzz when the time is over. I happen to have a collection of minute minders that are decorated in various ways, like a cat, a chef, and a kettle.

THE FORMAT FOR EACH LESSON

1. Turn on some soothing music and relax.
2. Copy five **X**s on your practice sheet.
3. Trace your letter five times.
4. Set your minute minder for writing each letter for the amount of minutes indicated.
5. When the bell rings, repeat steps 2, 3, and 4.

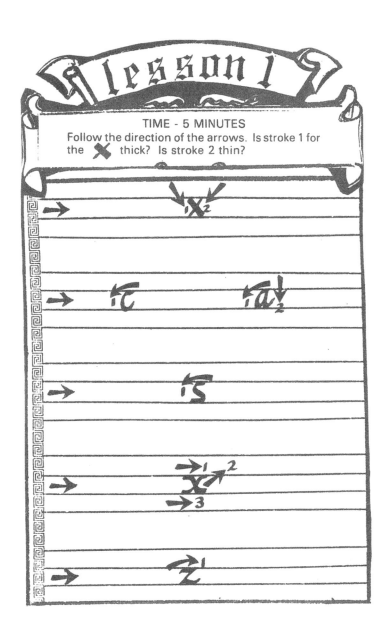

lesson 1

TIME - 5 MINUTES

Follow the direction of the arrows. Is stroke 1 for the ✘ thick? Is stroke 2 thin?

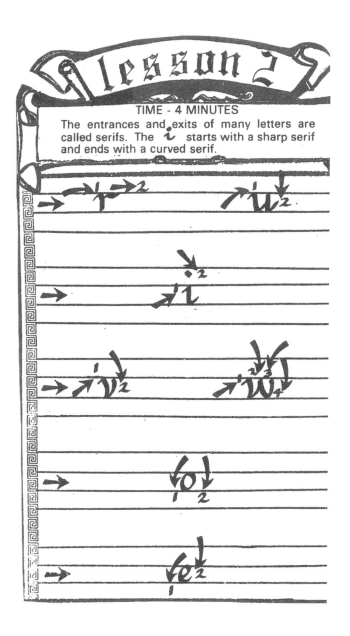

TIME - 4 MINUTES

The entrances and exits of many letters are called serifs. The *i* starts with a sharp serif and ends with a curved serif.

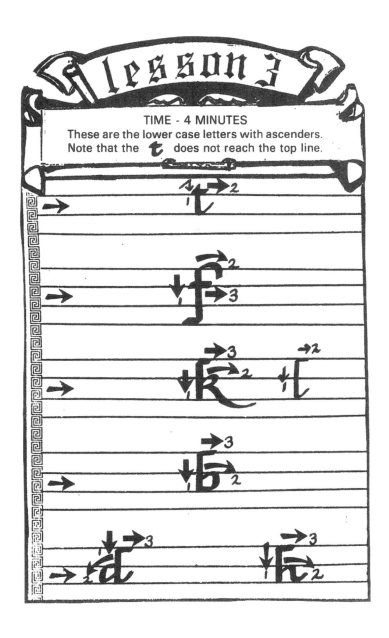

TIME - 4 MINUTES
These are the lower case letters with ascenders.
Note that the **t** does not reach the top line.

TIME - 4 MINUTES
The top letters have descenders ending in flat, push strokes. The last two letters have curved serifs.

TIME - 6 MINUTES

These capitals may be made larger if you so desire. At the beginning of a paragraph a larger capital is very effective.

TIME - 6 MINUTES

Are you practicing your 5 ✖ 's at the beginning of every lesson? You should, in order to maintain the proper pen angle.

lesson 7

TIME - 5 MINUTES

Do you have soft music playing in the background? Why not try Clair de Lune by Debussy.

TIME - 5 MINUTES
Are you using a timer? Practice each letter for a full 5 minutes.

Lesson 9

TIME - 7 MINUTES

These are beautiful capitals. It pays to practice them for a full 7 minutes each. Relax and enjoy!

TIME - 2 MINUTES

These old style figures and symbols complete your Romantic Calligraphy course. Congratulations!

Now that you've practiced my system of Romantic Calligraphy there are many ways to enhance your rocks. You can create art with a simple word or phrase. People love to get rocks as gifts with their names and/or positive messages.

JOYCE

JOHN

LOVE YOU

ENJOY

BE HAPPY

GOOD HEALTH

SMILE

CREATE

COURAGE

HAPPY BIRTHDAY

Once one of my grandsons called me and said, "Grandma, I'm in Florida. I'd like to visit you and introduce you to my special girlfriend. We can be over in an hour."

"Wonderful," I answered. "What's her name?"

"Jenny Nussbaum. She's a kindergarten teacher. She's attractive and has a good character. See you soon. I love you."

Immediately I got to work. I took out my rock-painting supplies and found a rock that had the word **"SMILE"** written on one side and nothing on the other side. I wrote **"JENNY"** on the other side. Frantically, I searched for a small box in the drawers of my dresser. When I found the right size, I put the rock in the box and gift-wrapped it.

When I presented the gift to Jenny, her sparkling brown eyes lit up. She was delighted with the unusual present. After the couple married Jenny asked me to teach her how to paint on rocks. She became proficient in it and I was proud to have been a happy influence in her life.

There was a time in my life when I was the president of a writing club. When my term expired after two years and I had to move on, I decided to give the members of the club a rock as a farewell gift. I used the Romantic Calligraphy letters to inscribe everyone's name on the respective rock that I presented to each. All were both surprised and impressed with the present, that represented a milestone (no pun originally intended) for me.

CHAPTER 9

CONCLUSION

Do you now agree that painting on rocks can be a fascinating and rewarding hobby? I hope so. During the COVID-19 pandemic it's important to keep busy at home with a pursuit you enjoy. I wish to stress that if you look closely at the samples of rocks that I created, you'll see plenty of mistakes. That's par for the course. I don't take these errors too seriously and I hope you'll feel the same way. The outcome is that you have something to keep you occupied and give you enjoyment all the while.

After you've painted some rocks you may wonder what to do with them. Let me remind you that you can glue some magnets to the smaller rocks and put them on the refrigerator door.

Rocks do make thoughtful presents, especially when you add the recipient's name. Another advantage is that rocks don't break like crystal or glass.

I put a few of my rocks in a local gift shop. I priced them in the low range and they have sold to satisfied customers. Though I haven't made money I have gotten a great deal of satisfaction. You may want to do the same. If you advance in your painting skills, and I hope very much you do, you can sell your rocks on Etsy.com. Some of professionally painted rocks advertised there do sell for quite high sums.

One time when I had a headache I put a rock on my forehead and the headache disappeared. The rock had absorbed the cold from my air conditioner. Rocks have thermal properties called conductivity and thermal mass or capacity. When you touch a rock, it sucks the heat away from your body and drops your skin temperature. I'm not a scientist, but I learned this accidentally. Try it! Good luck and God bless!

Printed in the United States
by Baker & Taylor Publisher Services